W9-BIB-856

Colored Pencil

WITH DEBRA K. YAUN

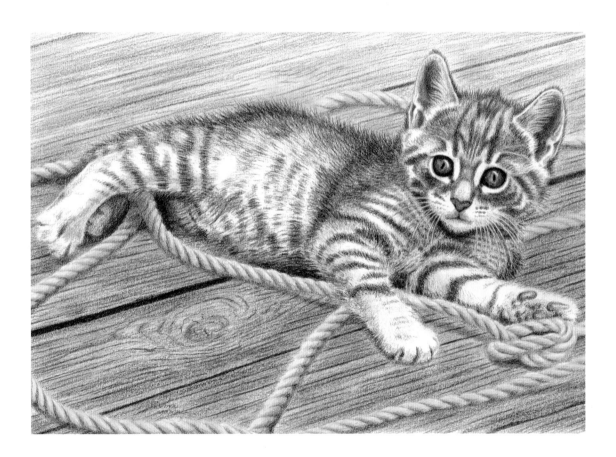

© 2003 Walter Foster Publishing, Inc. Artwork on cover and pages 1, 3, and 12–32 © 2003 Debra K. Yaun. All rights reserved. Walter Foster is a registered trademark. This book has been published to aid the aspiring artist. Reproduction of the work for study or finished art is permissible. Any art drawn or photomechanically reproduced from this publication for commercial purposes is forbidden without written consent from the publisher, Walter Foster Publishing, Inc.

REEVES
SINCE 1766

Contents

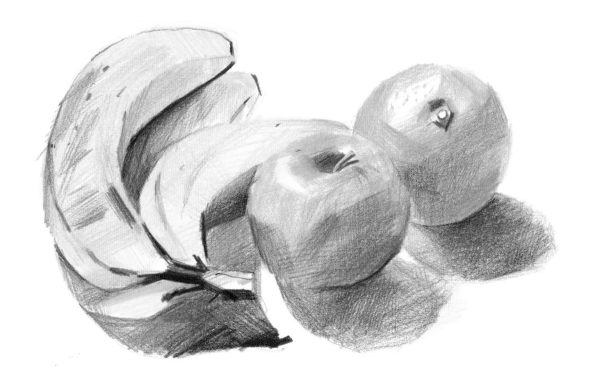

Introduction

Colored pencil is a versatile medium —it can be used to replicate the look of oil, watercolor, acrylic, and more. Although it has been used as a fine art medium for less than a century, its popularity has grown significantly over the last few decades. And it's easy to understand why more and more artists are attracted to colored pencils—they are fairly inexpensive and convenient to transport. They are also nontoxic, readily available in art and craft stores, and combine well with other media.

Whether you choose to use colored pencils for sketches or to create fully rendered drawings, you will find that these pencils are brightly hued and precise tools that are a joy to work with. There are many different approaches and techniques to discover in colored pencil art—from layering and hatching to burnishing and blending. As you explore this art form, you'll discover many methods and materials that will help you realize the seemingly endless creative possibilities working with colored pencil offers. The important thing is to have fun while you develop your own artistic style—and enjoy creating your own works of art in colored pencil!

Tools and Materials

You don't need many supplies to get started drawing with colored pencil, so you won't have to invest a lot of money in materials. All you need in the beginning are a few basic colors, an eraser, a sharpener, and some paper. Then, after you've become more familiar with the variety of effects you can create, you may want to purchase a few more specialized tools. You'll find that, as colored pencil is rapidly becoming a more popular medium, many new products are being developed to aid the colored pencil artist.

Pencils

Reeves offers several sets of quality colored pencils that each provide a good starting palette for beginners. If you would like to purchase additional colors, many art stores sell colored pencils individually as well. Once you've chosen your colors, make sure to store your pencils upright or safely in a container—and try not to drop them. Colored pencil lead is very brittle, and the lead is likely to break inside the shaft if the pencil is dropped. You may not be able to tell by looking that the lead is broken somewhere inside the pencil, but such breaks will eventually render the pencil useless.

Erasers

You'll want to use a kneaded eraser to correct your colored pencil drawings. It erases the color gently, whereas the friction between a rubber or vinyl eraser and the paper will melt the wax pigment and flatten the *tooth* (the grain) of the paper. To remove small amounts of color, twist or pinch the eraser into the size and shape you want, and then press it lightly on the page to pick up the pigment. When the eraser gets "dirty" and is not as effective at lifting the color, knead it (like dough) with your fingers to reveal a clean surface. Another option for removing color is to use a small battery-powered eraser; it also erases without crushing the paper underneath.

SUPPLIES Since 1766, Reeves has been manufacturing excellent-quality paints and brushes and has long been established around the world as a wonderful source of art material for beginners. Now Reeves colored pencils are available at art supply stores everywhere.

Papers

The paper you work on—your *support*—can have a great impact on your artwork. Smooth paper has an even surface, and its lack of texture makes it ideal for creating glossy blends of color. You can also purchase a variety of textured papers (including illustration boards and watercolor papers) at art supply stores. The rough grain of textured paper "catches" the color so it accepts more pigment than smooth paper does. And you may want to consider using colored papers for your drawings. (For more on colored supports and their effects, see "Colored Grounds" on page 11.) In addition to purchasing paper for final pieces, you may want to buy a sketch pad or a sketchbook for practice sketches or for making quick studies when traveling or when drawing outdoors.

Sharpeners

You can achieve different effects depending on how dull or sharp your pencil is, but generally you'll want to make sure your pencils are sharpened at all times; a sharp point will ultimately provide a smoother and more intense layer of color. Although a small handheld sharpener will suffice, an electric or battery-powered sharpener is better-suited for fine art purposes as it hones the pencil more cleanly. You can also use a sandpaper pad to refine the pencil points, but remember to sand them gently if you want very fine points.

Extras

In addition to the basic supplies already mentioned, you may want a dust brush to gently remove the pencil residue from your paper, a spray-on fixative to preserve your finished drawing, and a paper blending stump (also called a "tortillon") to create soft blends. A pencil extender is handy when the pencil gets too short to hold comfortably, and you may want a triangle for making straight lines and artists' tape for masking. It's also nice to have white gouache (opaque watercolor-type paint) and a small paintbrush on hand for adding tiny highlights.

Color Theory

Colored pencils are transparent by nature, so instead of "mixing" colors as you would for painting, you create blends by layering colors on top of one another. Knowing a little about basic color theory can help you tremendously in drawing with colored pencils. The *primary* colors (red, yellow, and blue) are the three basic colors that can't be created by mixing other colors; all other colors are derived from these three. *Secondary* colors (orange, green, and purple) are each a combination of two primaries, and *tertiary* colors (red-orange, red-purple, yellow-orange, yellow-green, blue-green, and blue-purple) are a combination of a primary color and a secondary color. *Hue* refers to the color itself, such as blue or purple, and *intensity* means the strength or chroma of a color (usually gauged by pressure applied or pencil quality in colored pencil).

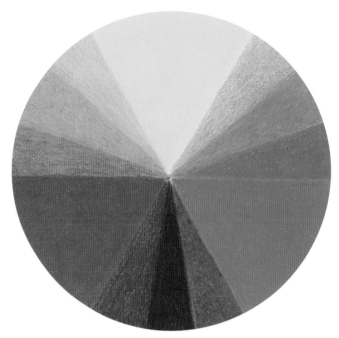

COLOR WHEEL A color wheel can be a useful reference tool for understanding color relationships. Knowing where each color lies on the color wheel makes it easy to understand how colors relate to and interact with one another.

Color Psychology

Colors are often referred to in terms of *temperature,* but the term isn't meant to be taken literally. If you think of the color wheel as divided into two halves, you can get a clear idea of the concept. The colors on the red side are considered warm, while the colors on the blue side are cool. Thus colors with red or yellow in them appear warmer, and colors with more green or blue in them appear cooler. Also keep in mind that warm colors appear to come forward and cool colors appear to recede; this knowledge is valuable when creating the illusion of depth in a scene.

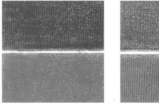

USING COMPLEMENTS When placed next to each other, complementary colors create lively, exciting contrasts. So pairing two complements in your drawings will make your subject to seem to "pop" off the paper. For example, you could place a red cardinal in a green, leafy tree or depict a mixed bouquet of yellow daffodils and purple irises.

Complementary and Analogous Colors

Complementary colors are any two colors directly across each other on the color wheel (such as red and green, orange and blue, or yellow and purple). *Analogous* colors are those that are adjacent to one another (for example, yellow, yellow-orange, and orange).

Value

Value is the term used to describe the relative lightness or darkness of a color (or of black). It is the manipulation of values that creates the illusion of form in a drawing, as shown in the development of the sphere at right. For more on value and colored pencil, see "Pressure" on page 6.

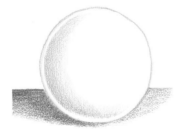

CREATING FORM Draw the basic shape or outline of the object. Then, starting on the shadowed side, begin building up color, leaving the paper white in the area where the light hits directly.

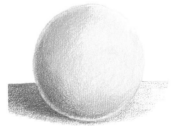

VARYING VALUES Continue adding color, gradually deepening the values to create the spherical form of the ball. Squint your eyes to blur the details, so you can focus on the value changes.

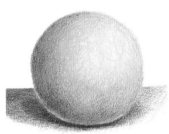

BUILDING DEPTH Add the darkest values last. As the sphere curves away from the light, the values become darker, so place the darkest values on the side directly opposite the light.

Colored Pencil Techniques

Colored pencil is amazingly satisfying to work with, partly because it's so easily manipulated and controlled. The way you sharpen your pencil, the way you hold it, and the amount of pressure you apply will all affect the strokes you create. With colored pencils, you can create everything from soft blends to brilliant highlights to realistic textures.

Once you're familiar with the basic techniques, you'll be able to decide which will best enable you to capture your subject's unique qualities. There are as many techniques in the art of colored pencil as there are effects you'd want to re-create—and the more you practice and experiment, the more potential you will see in the images that inspire you.

Strokes

Each line you make in a colored pencil drawing is important—and the direction, width, and texture of the line you draw will all contribute to the effects you create. Practice making different strokes, as shown in these examples. Apply light, medium, and heavy pressure; use the side and then the point of your pencil; and experiment with long, sweeping strokes as well as short, precise ones. The more familiar you are with the wide array of strokes you can create, the easier it will be for you to re-create the textures and objects you observe.

Light pressure　　**Medium pressure**　　**Heavy pressure**

PRESSURE Varying the amount of pressure you use on your pencil is an easy way to make transitions between values. Since colored pencils are translucent, the color of the paper underneath will show through. With light pressure, the color is almost transparent. Medium pressure creates a good foundation for layering, and heavy pressure flattens the paper texture, making the color appear almost solid.

STROKES AND MOVEMENT Although a group of straight lines can suggest direction, a group of slightly curved lines conveys a sense of motion more clearly. Try combining a variety of strokes to create a more turbulent, busy design. Exercises like these can give you an idea of how the lines and strokes you draw can be expressive as well as descriptive.

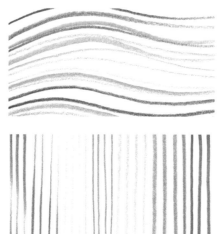

VARIED LINE Try varying the width and weight of the lines you create to add more texture and interest. These calligraphic lines can help create a feeling of dimension in your drawing.

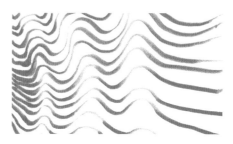

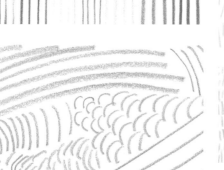

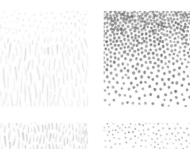

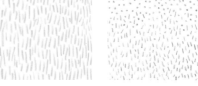

STROKES AND TEXTURE You can imitate a number of different textures by creating patterns of dots and dashes on the paper. To create dense, even dots, try twisting the point of your pencil on the paper.

Hatching

The term *hatching* refers to creating a series of roughly parallel lines. The density of color you create with hatch strokes depends on the weight of the lines you draw and how much space you leave between them. *Cross-hatching* is laying one set of hatched lines over another but in the opposite direction, producing a meshlike pattern. Hatch and cross-hatch strokes can both be used to fill in an almost solid area of color, or they can be used to create texture, as shown at right.

CROSS-HATCHED SPACING Filling in space with cross-hatch strokes in random directions creates the dense, haphazard texture shown above. For a smoother, more even texture, make cross-hatch strokes in two directions only (left leaning and right leaning).

Handling the Pencil

Although there is no single "correct" method for holding the pencil, the way you do so will have a direct impact on the strokes you create. Some grips will allow you to press more firmly on the pencil, which will result in dark, dense strokes. Others hinder the amount of pressure you can apply, effectively rendering your strokes lighter. Still others give you greater control over the pencil, allowing you to create fine details. Try each of the grips below, and choose those that are the most comfortable and create the effects you desire.

CONVENTIONAL GRIP For the most control, grasp the pencil about 1-1/2" from the tip. Hold it the same way you write, with the pencil resting firmly against your middle finger. This grip is perfect for smooth applications of color, as well as for making hatch strokes and small, circular strokes. Try to relax and let the pencil glide across the page.

 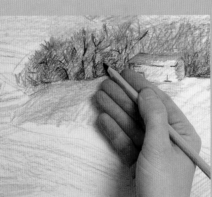

OVERHAND GRIP Guide the pencil by laying your index finger along the shaft. This is the best grip for strong applications of color made with heavy pressure.

UNDERHAND GRIP When you cradle the pencil in your hand (as in either example shown above), you control it by applying pressure only with the thumb and index finger. This grip can produce a lighter line, but keep in mind that when you hold the pencil this way, your whole hand should move (not just your wrist and fingers).

Layering and Blending

Because colored pencils are translucent, artists use a transparent layering process to either build up color or create new hues. This layering process is wonderful because it creates a much richer hue than you could ever achieve if you were using just one pure color. To deepen a color, layer more of the same over it; to dull it, use its complement. If you want to blend your strokes together, you can also use a colorless blender, as shown at the bottom of the page.

LAYERING WITH HATCH STROKES In the examples at right, yellow, orange, red, and blue were layered on top of one another with cross-hatch strokes to demonstrate one way of creating a new color. To avoid getting a hue that's too dark, begin with the lightest color and work up to the darkest. This way you can tell if the mix is getting too muddy or deep before it's too late.

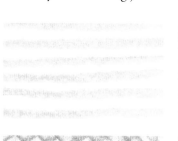
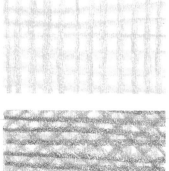

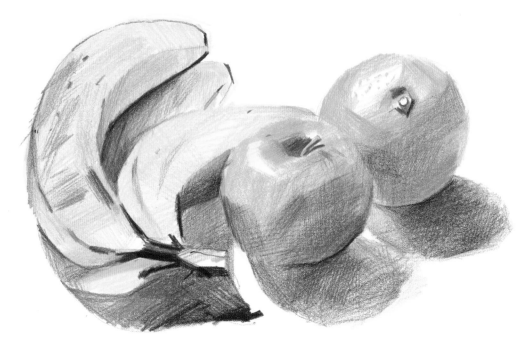

BUILDING UP COLOR Here is a simple still life rendered with layers of hatch strokes. The forms of the fruit were built up by layering different values of the same color; then they were dulled a bit with a touch of their complements. Notice that the shadows under the fruit are blends of many different colors; they are never just gray or black.

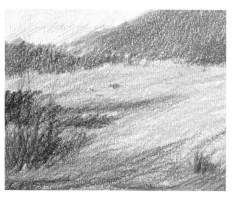

COLORLESS BLENDER This special marker dissolves the pigment, creating a smooth, solid color. Apply it over the pigment, as shown here, or on the blank paper before you add color.

USING A COLORLESS BLENDER The example at left shows a quick study created with colored pencils. In the second version at right, a colorless blender was used to blend the pigments. Notice how much smoother the strokes appear after blending. The surface of the paper also becomes a little slick after using the blender, so any colors you add over the blended layer will glide easily on the page.

Burnishing

Burnishing (or opaque layering) is a blending technique that requires heavy pressure to meld two or more colors, which also flattens the tooth of the paper. Usually a heavy layer of white (or another light color) is applied over darker colors to create a smooth, shiny blend, as shown in the example below. Try not to press too hard on the underlayers of the area you intend to burnish; if you flatten the paper too soon, the resulting blend won't be as effective.

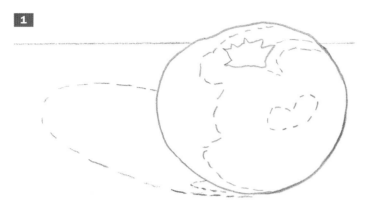

STEP ONE Begin with a line drawing in the *local* color (the actual color of the object) so the outline won't be visible when you're done. Press lightly so the outlines aren't impressed into the paper surface, creating dents. Here the solid lines indicate where hard edges will be, and the dashes or broken lines denote areas for soft edges and shadows.

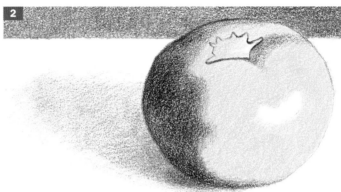

STEP TWO As you fill in the outlines with layers of color, keep the pencils sharp. Apply light to medium pressure as you slowly build color from light to dark. Use short, controlled strokes for a smooth tone, gradually lessening the pressure at the edges to make them soft. Here the darkest areas are created with green, the complement of red.

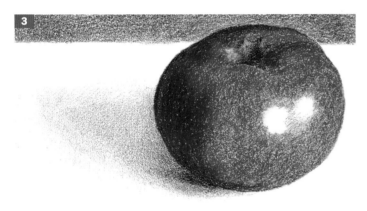

STEP THREE Next layer the different values of red and green, using heavier pressure. Be sure to fill in any highlights with white; this will act as a sort of barrier against saturation from the other colors.

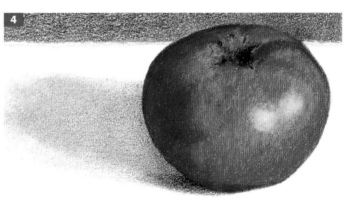

STEP FOUR Finish with a semi-sharp white pencil and circular strokes to burnish first the highlights and then the rest of the object. You may need to burnish over the same areas more than once to get an even blend.

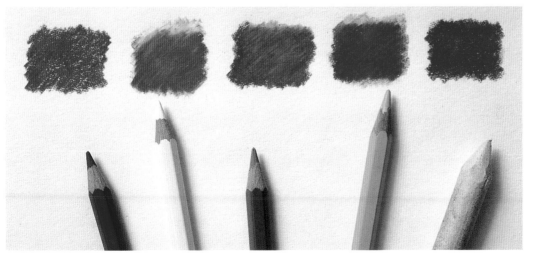

EFFECTS OF BURNISHING Here various colors and techniques were used to burnish over the same red hue. At far left is the original, untouched color. To the right of that is shown the effect of burnishing with white, with blue, and with yellow, in that order. At far right, a blending stump was used to burnish the color. There are also colorless (without pigment) blending pencils available that many artists prefer—they are nontoxic and easy to use.

Special Effects and Techniques

As you're working in colored pencil, you may sometimes need to go beyond the basics and use some specialized techniques and materials, like the ones shown here. For example, you may choose to use black paper to provide a dramatic backdrop, lift off color with tape to reveal highlights, or make impressed lines to create texture. There are literally hundreds of possible special techniques, so feel free to invent your own!

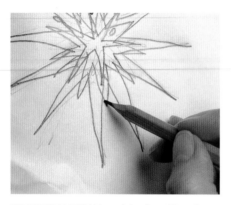

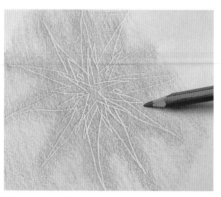

IMPRESSED LINE To resist color with an impressed line, draw a design on tracing paper. Place it over your drawing paper, and trace over it firmly to leave an impression on the paper underneath. (You can also press lines directly into the paper with your fingernail or a stylus.) Then lightly shade over the impressions, using the side of the pencil to avoid filling in the lines completely.

USING STENCILS For a stylized pattern, cut out a stencil and draw the shape repeatedly on your paper. For the pattern above, randomly fill in the shapes with a variety of colors.

USING TRANSPARENT TAPE TO ERASE For soft highlights, such as the light line shown on the pencil at right, place transparent tape over the area. Then use a stylus to draw over the tape where you want to remove color. Carefully lift off the tape; then repair the spots where too much color was lifted. Try testing this on your paper before drawing, since some papers could be damaged by this technique. And if the tape removes too much color, stick the tape to your clothing first (to remove some of the tack) and then try again.

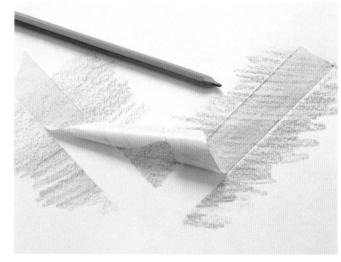

USING INK Using a fine-tipped, permanent marker is an interesting way to create dark values, as in this leaf. When you layer translucent pencil over the ink, the ink will show through, creating a darker value than you'd get with pencil alone. Just be sure to use a smudge-proof marker so the ink won't smear on your drawing paper.

MASKING WITH TAPE You can use artists' tape or masking tape to create clean lines and simple borders, as shown above. Just place the tape where you want it, apply color over it, and then remove it to reveal clean lines underneath.

FROTTAGE Rubbing over a textured surface, like the leaf at right, with the side of a pencil is a technique called "frottage." This creates an impression of the object (and its texture) on your paper.

Watersoluble Pencils

Watersoluble, or watercolor, pencils offer the same amount of control and detail as regular colored pencils do, but they have the added versatility of being similar to painting tools as well. When you blend them with a brush and water, the artwork you create will have a softer and more painterly look. You can also use watercolor pencils to create a base coat or underpainting for your colored pencil drawings.

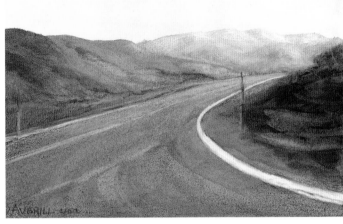

WATERSOLUBLE PENCIL You can blend watersoluble pencils with a wet brush (see example at top left) to create soft blends. This effect is also shown in the example above, in the sky, in the hills, and on the road. The rest of the scene was created with regular wax-based colored pencils.

Special Papers

You can also use any of a number of colored grounds, multimedia panels, illustration boards, and specialty papers (such as velour, sandpaper, or mylar) for your colored pencil drawings. Each type of support will give you a different result—some offer more texture or provide an undercolor, and others are better suited for mixed-media projects. When choosing paper, make sure you select one of high quality, and test out the pencils and techniques you plan to use ahead of time.

COLORED GROUNDS If you choose a colored support that shares a dominant hue in your drawing, you can create harmony among the colors in your drawing and save a significant amount of time—the paper provides a medium value to build color on (see example at far right). Make a test sheet first on the back of your paper (or on a scrap piece of paper, as shown near right) to see how the colors in your palette will be affected by the colored ground you choose.

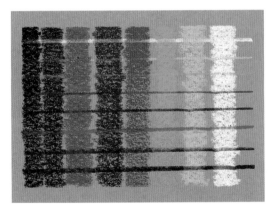

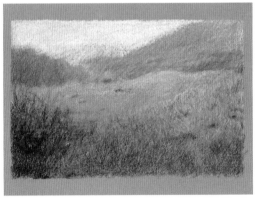

BLACK PAPER The contrast of light colors on black paper creates a sense of drama. Bright, colorful subjects appear even bolder over a dark ground. For the most brilliant hues, apply a layer of white before applying color over it.

SANDED PAPER "Sanded paper" has a gritty quality to it that lends an interesting texture to colored pencil art. The rough surface will sand off the point of your pencil, though, so make sure to keep a dust brush handy to sweep away the residue.

ROUGH TEXTURE Paper with a heavy tooth adds a rough texture to your work. Because the deep grain "catches" the pigment, you can get very rich, deep dark values.

Lesson One: Parrot

Making the Best of a Limited Palette

An artist may choose a *limited palette* (just a few colors) for convenience, experimentation, or the desire to express a particular mood in a scene (such as using only blues and greens to depict a somber mood). Working with a limited palette can also force you to think creatively—you must carefully plan your values, blend and build up colors that you don't have in your palette, and use special techniques to achieve the effects you want. It's certainly simpler to depict a colorful subject with a huge selection of colors, but consider challenging yourself by working with a limited palette; you may be surprised by the results. In this example of a colorful parrot (and in all of the lessons in this book), Debra Yaun admirably extracts an amazing array of brilliant hues from only eight colors.

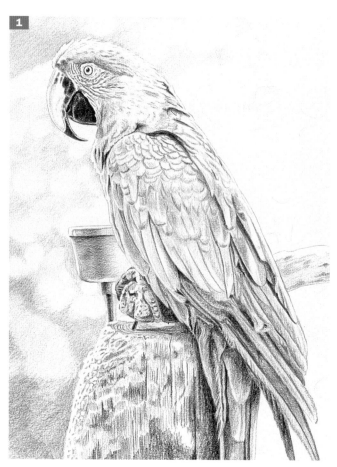

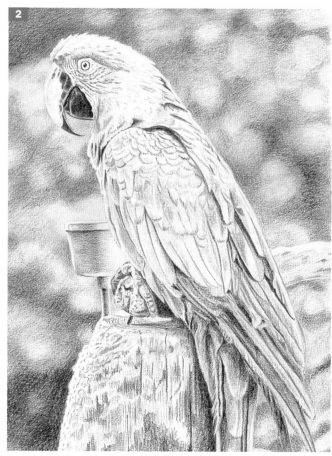

STEP ONE I start with a sketch on practice paper, and then I transfer the drawing to my art paper. To do this, I cover the back with graphite (creating a sort of carbon paper). Then I place the drawing, graphite-side down, over my art paper and trace over the lines, effectively transferring the sketch to my drawing paper. Now I'm ready for color. I fill in the darkest areas first, using small, circular strokes of black colored pencil and smoothly applying the color to the feathers and the beak. I also use black for the shadows of the feet, the cup, and the perch, leaving some white along the edges to indicate the strong back lighting. Then I apply black in the background, forming some abstract shapes with smooth, circular strokes.

STEP TWO Now I darken the background with more black, adjusting the shapes for balance and interest but keeping them blurred so they don't compete with the subject. Then I add a layer of cobalt blue over the black, applying the color with circular strokes to keep the layers soft and blended.

Below are the eight colors Debra Yaun uses for the projects in this book. Keep in mind that the names of the colors may vary among brands; sometimes two pencils that have the same name are two different hues.

| Magenta | Peach | Yellow | Forest Green | Dark Umber | Cobalt Blue | White | Black |

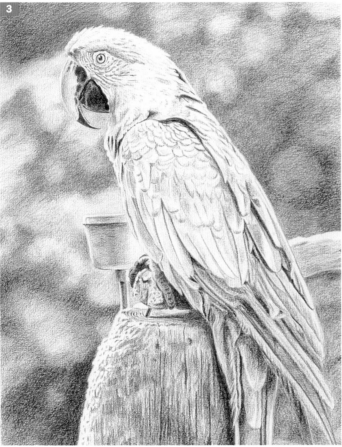

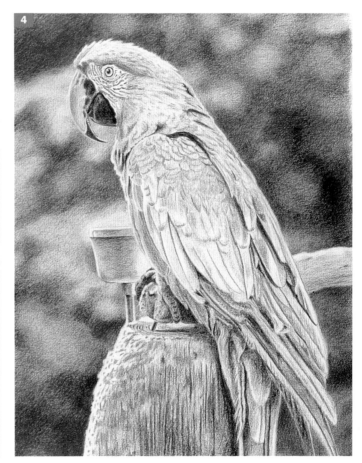

STEP THREE Next I add a little more cobalt blue to the background, to the iris of the eye, around the outside of the eye, and along the white area near the beak. I also apply blue with medium pressure over the black parts of the beak and feet and add blue to the bird's cast shadow. Then I stroke peach on the upper beak with a smooth, circular motion, leaving the white highlight at the outer edge. I also add some peach to the black areas of the beak to create small, cracklike lines. Then I apply peach lightly and smoothly to the cup, the wood perch, and the wood support, leaving the highlights white. Next I darken the wood a bit more with some black, using strokes that follow the direction of the wood grain.

STEP FOUR I smoothly apply yellow to the beak, over the peach, using medium pressure. Then I add yellow to the head, the details around the eye, the chest, the top part of the wing, and the back. I layer some cobalt blue over the more shadowed areas of the head and over the black lines in the feathers. Next I lightly apply yellow to the cup, overlapping the white area a little. I also layer yellow over all the wood and on some of the light spots in the background. Then I apply dark green to the background, pressing firmly in small, circular motions over the darker areas. I make sure to keep my pencils sharp to help work the color into the paper. Then, using a blending stump, I soften the background colors with small, circular motions.

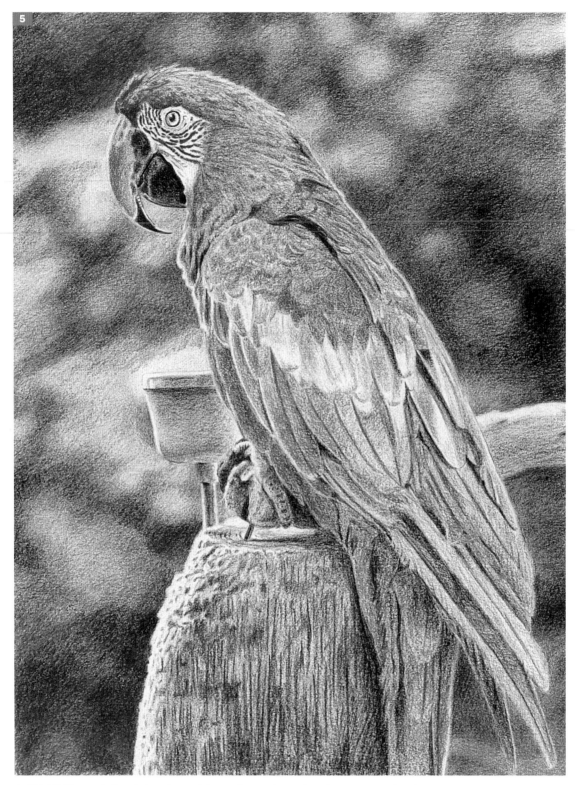

STEP FIVE I apply first dark umber and then yellow to the perch with short, vertical strokes that mimic the wood grain. I also give the cup a light layer of dark umber, but I leave the edges white to indicate reflections of the strong sunlight. Since I don't have red in the limited palette I'm using, I must build a red hue by repeatedly layering magenta and yellow over each other. I begin with a layer of magenta to the head, using medium pressure and short strokes that follow the direction the feathers lie and allowing the yellow to show through along the top of the sunlit head. Next I apply magenta firmly to the spots on the face and under the eye, and then I go over the spots with a little more yellow to create an orange-red. I lightly add a little magenta on the beak and apply a layer of cobalt blue to a lower row of feathers, pressing firmly. Then I blend the feathers with the blending stump and add light layers of magenta and blue to the long wing and tail feathers.

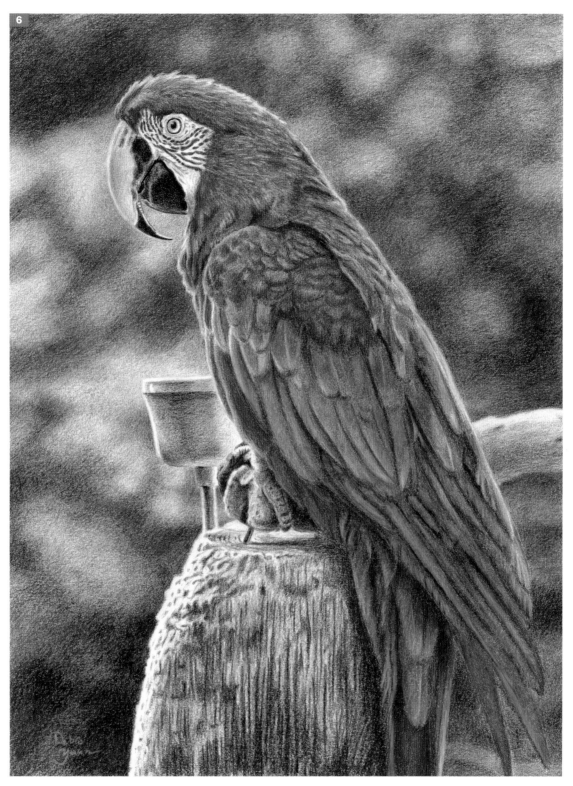

STEP SIX Next I apply first dark green and then yellow to the middle row of feathers. I layer more magenta on the head, and then I add white to a few areas to create lighter feathers on top. I add magenta to the cup to create the reflection and add a little more black to the center of the cup to give it some dimension. To balance the dark green behind the parrot's head, I add some dark umber in a circular motion. Then I use cobalt blue to smooth and blend the colors in the background and in the feathers. I use a blending stump to work in the color, and I apply white over the blue, pressing firmly to create some shine on the feathers. I use black to emphasize the edges of the tail feathers and blend it in with a blending stump. I lightly work magenta into some of the dark areas of the blue feathers and the one red tail feather, and I darken the edges of the red feathers with dark umber and black. Finally I add highlights with touches of white over the blue tail feathers.

Lesson 2: Daylilies

Starting with a Simple Subject

Intricate, complex scenes are certainly visually interesting, but they can also be challenging to draw. A better way to begin is to choose a simple subject, which can be equally compelling. Before you start drawing, look closely at your subject and try to break it down into basic shapes (such as circles, triangles, and wedges). You can also reduce the distractions in your scene by keeping the background vague, as in this simple portrayal of colorful daylilies.

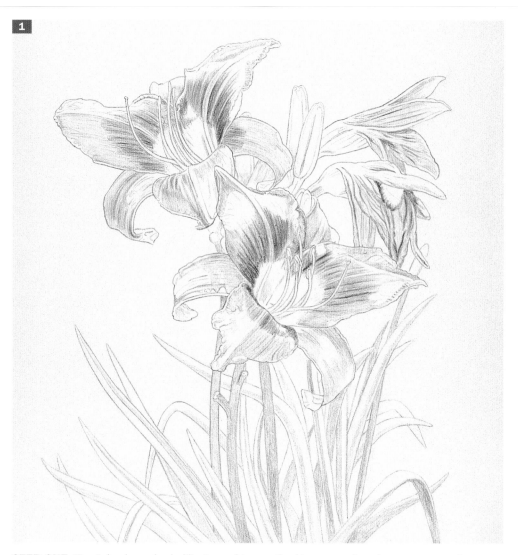

STEP ONE First I sketch out the daylilies in graphite pencil, taking care to draw the correct proportions. Then I use black colored pencil to indicate the darkest veins on the flower petals, creating long strokes that start at the center of each flower. I am using a grisaille technique here (see box on page 27), applying black colored pencil to the stems and leaves with short, even strokes. This will establish a foundation for all the subsequent values in the drawing.

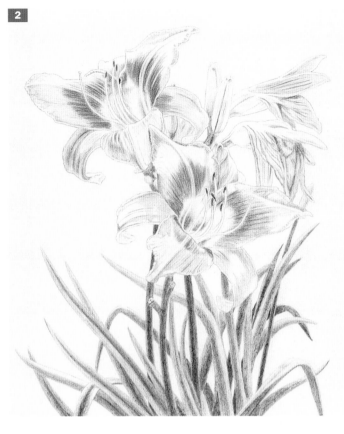

STEP TWO Next I lightly apply short strokes of cobalt blue over the black on the leaves. I also layer blue over the rest of the leaves, but I retain some of the white of my paper on the leaves in the foreground. This helps make the background leaves seem to set behind the foreground leaves. I give the stems a little heavier application of blue, since they appear a bit darker in my reference photo.

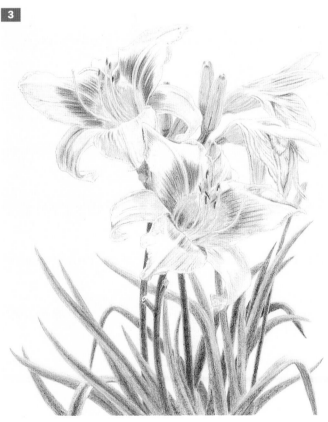

STEP THREE With short strokes, I add a light layer of dark green to the centers of the two open flowers. Then I apply dark umber to the ends of the stamens, leaving the pollen edges white. I use short strokes of dark green along the length of the leaves and stems, and then I lightly layer dark green on the flower buds and on the bases of the two closed flowers. Next I add dark umber to the stems and some of the darker leaves and layer yellow over the green buds and leaves, using a paper blending stump to soften the colors. Then I apply more yellow to the leaves in the foreground. (Keep in mind that warm colors appear to "pop" forward.) I layer black on the base of the stamen to indicate the shadow and apply a fairly heavy layer of yellow to the centers of the flowers. Then I use yellow to indicate pollen on the stamens, leaving a white edge for contrast.

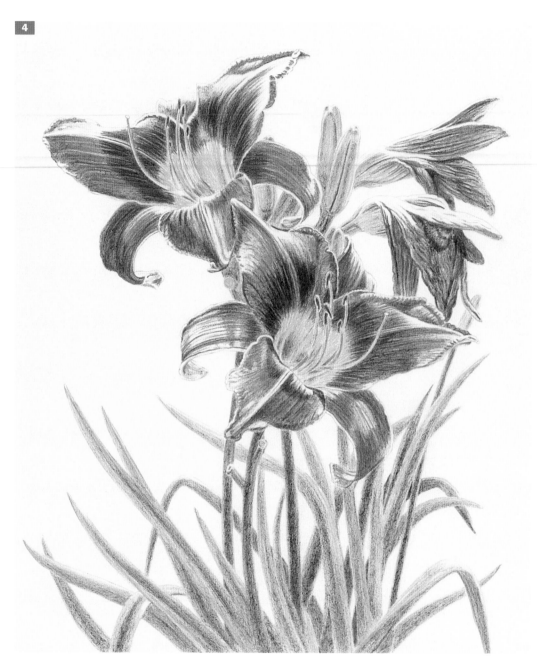

STEP FOUR Using strokes that follow the direction of the veins, I add a layer of magenta to the open petals, leaving some white to indicate the sunlit areas. To achieve a "glow" on the petals, I layer magenta over the yellow to create orange; notice also that the cobalt blue I've added shows through under the magenta, creating a purple hue. Developing this variety of reds gives a better contrast between the shadows and the lighter areas. Next I lightly apply magenta along the petal lines and inner edges of the buds to indicate some reflected color from the surrounding flowers. I give the closed flowers a layer of magenta as well, pressing firmly where the petals fold. Then I layer magenta over the brown on the ends of the stamens to darken and warm them.

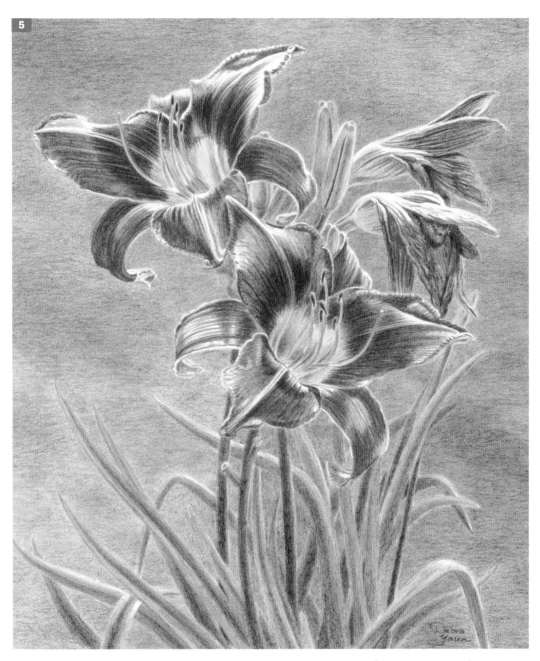

STEP FIVE Next I erase any graphite lines that are still visible along the outside of the petals. Using medium pressure, I apply a layer of cobalt blue to the background with horizontal strokes. I keep the point of the pencil very sharp and stroke along the edges of the petals. Then I layer dark green and magenta onto the blue in horizontal strokes to add some color and interest to the background. Next I use a paper blending stump to soften and blend the background colors; I want to make sure I don't have a complex or distracting backdrop that would detract from these simple flowers. Finally I take another look at the leaves and decide they seem a little light, so I darken them in a few areas with some blue and more dark green.

Lesson 3: Bell and Flowers

Using References

Observing nature firsthand is a wonderful practice for an artist. Be sure to bring a sketchbook with you so you can make some field sketches on site—these quick studies can be invaluable reference tools when you return to your studio. If you bring your camera along, you have the option of observing and recording a subject from several different angles. You can also snap various shots of the entire setting, as well as some closeups of the details. Always give yourself as much information to work with as you can. When you return to the studio, you can compile your photos—and any drawings, magazine clippings, and other static references you have—into a permanent file for future use (also called an "artist's morgue"). In this example, Debra portrays a colorful floral scene using a photo from her reference file.

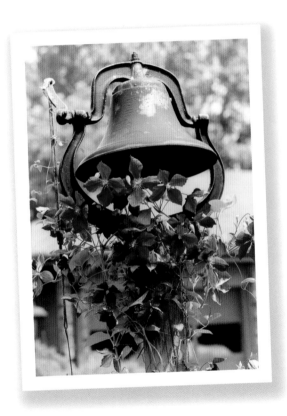

USING PHOTOS Many artists prefer to draw on location, but I almost always work from my own photographs. Working from photos allows me to study every detail of my subject closely and to render it as realistically as possible.

1

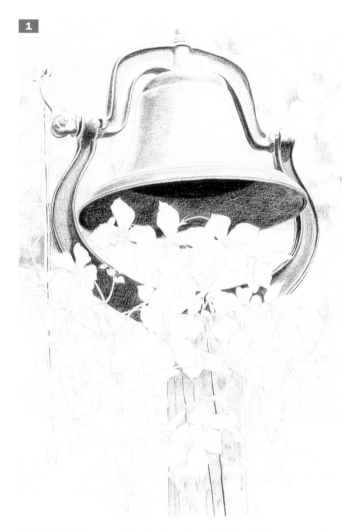

STEP ONE I use a grid method to draw the bell and flowers to make sure I transfer the proportions correctly. To do so, I draw a grid onto a small piece of tracing paper and place it over the photo; then I draw a proportionate grid on my drawing paper and copy the lines from each square. I simplify the drawing by leaving out a few flowers and vines and omit the wire that wraps around the post. Then I apply black colored pencil to the darkest shadows of the bell and post and add a heavy layer of black to the center of the bell.

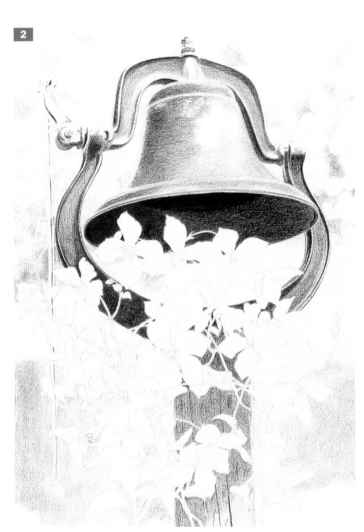

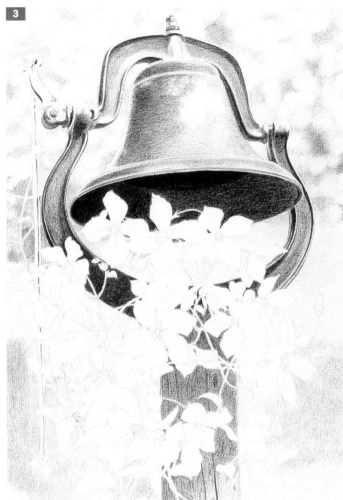

STEP TWO I apply a light layer of black to the background with small, circular strokes. Referring to my photo, I add a light layer of cobalt blue to the bell and the metal stand (over the black) to create a cool gray. I also draw the blue out past the black onto the white paper here and there, leaving some white areas to indicate highlights. Next I apply blue to the darker areas of the post to "push" it back into shadows. Then I use vertical strokes to add a light layer of dark umber over the whole post, and I lightly apply yellow to the bottom of the post.

STEP THREE I add cobalt blue over the center and upper portions of the background, using light, circular strokes. Then I add black to the lower part of the background and blend it in with a blending stump. I want to simplify this area of the background to focus the attention on the flowering vine. At the bottom of the paper, I add a layer of blue and then dark green to the background to vaguely represent foliage.

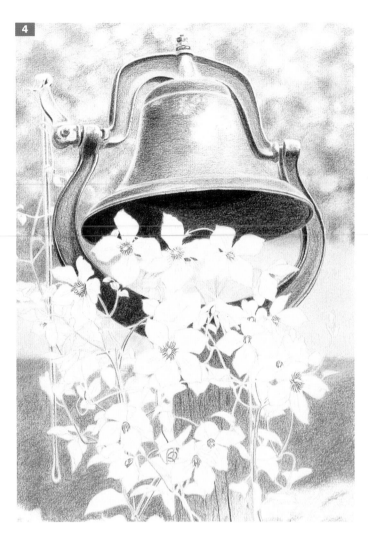

STEP FOUR Next I layer dark umber in a few areas over the blue in the lower background and outline the flower centers and stems. Then I add cobalt blue to a few leaves and the rope, and I layer dark green over the background at the top. I apply dark umber to the top of the bell and handle and soften the light blue area in the middle with a blending stump. I give the bottom of the background a layer of blue and smooth it with a blending stump. Then I layer white over the blue in the middle background, and I layer yellow over the upper background. I lightly add black to the flowers, indicating the lines in the petals and the shadows. Next I add dark green and then blue to the background at the bottom and blend it in with a blending stump.

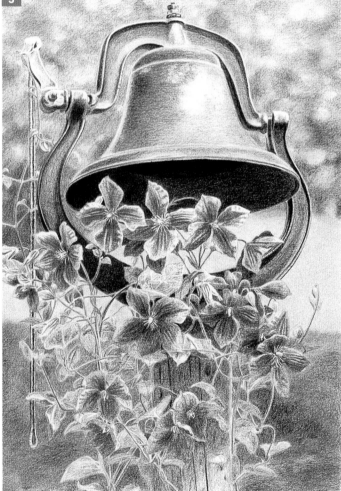

STEP FIVE I sharpen my dark green pencil and add some detail to the leaves. Then, using medium pressure, I apply dark umber to more stems and layer magenta over the black lines and over the shading on the petals. I leave the petal highlights white, but I add a little black to a few of the petals to darken them. I don't have the exact color of the petals in the limited palette I'm using here, but I can create it with layers of magenta, blue, and black. I use small circular strokes of black over the background at the bottom to darken it, and I add black to the bellpull to give it more dimension.

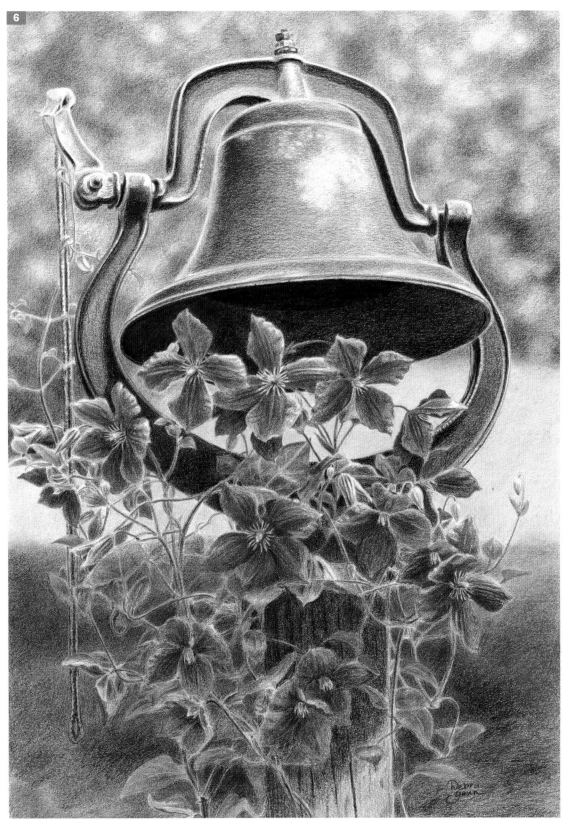

STEP SIX Next I add yellow to some of the leaves, and I darken parts of the background with small circular strokes of cobalt blue. As I add more blue to the magenta flowers, I create a darker purple on the petals. Then I darken some of the leaves with dark green, apply yellow to the center of the flowers, and add more magenta to the petals. I add another layer of black and one of blue to the background, pressing firmly to blend all the layers. Then I apply a little more black to the bell handle and stand for more contrast. Finally I use white to soften the edges on the petals and buds.

Lesson 4: Kitten

Drawing Animals Accurately

Animals are wonderful subjects to draw because there are so many different kinds to choose from, and they all have their own distinctive features and textures—whether they are smooth and scaled, fluffy and feathered, or soft and furry. In this adorable depiction of "Spike," Debra uses soft blending and intricate layering techniques to convey the distinctive striped patterns in the soft, silky fur of this cuddly, playful kitten.

COMPARING FOR ACCURACY
As I work, I often check my drawing for accuracy by turning it and my reference photo upside down and comparing the two. Looking at them both upside down makes it easier to spot any problems because you're forced to really see the actual object, rather than relying on any preconceptions you may have about what the subject should look like.

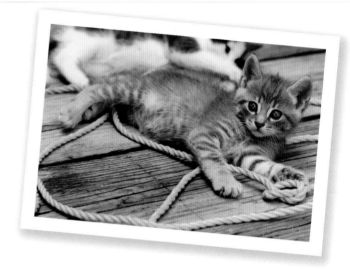

STEP ONE Before I start drawing, I decide to use some artistic license and make a few slight adjustments from my photo. Then I begin by sketching out the kitten on practice paper, where I make sure I capture Spike's features and proportions accurately. I transfer the drawing to my art paper and erase any excess pencil lines with a kneaded eraser. Next I apply black to the darkest areas around the kitten and lightly layer over the gray areas of the fur. At this point I'm not worried about creating texture; I just apply the various gray values with a fairly sharp pencil, using a circular motion. Then I use gray to fill in around the areas of lighter fur and the area around the whiskers, leaving the whiskers white.

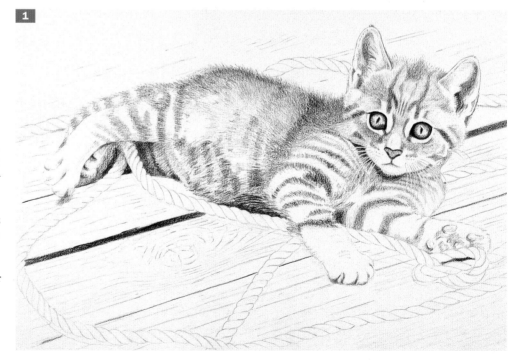

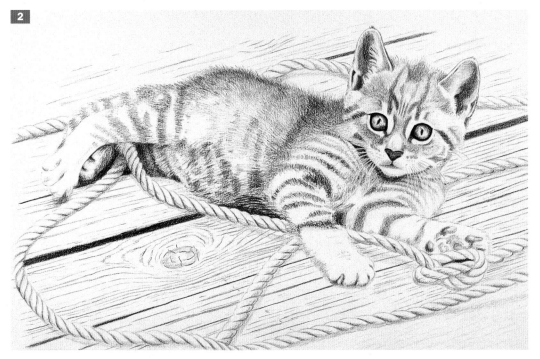

STEP TWO Next I apply a light layer of peach to the insides of the ears, to the nose, to the belly, and around the mouth, using circular strokes. I give the upturned paw pads a layer of peach, but I leave the highlights white. I add a light layer of dark umber to the rope and then add a heavier layer on the shadowed side. I also work a light layer of dark umber into the fur and over the paw pads. I detail the wood with black, making sure all the strokes follow the direction of the wood grain.

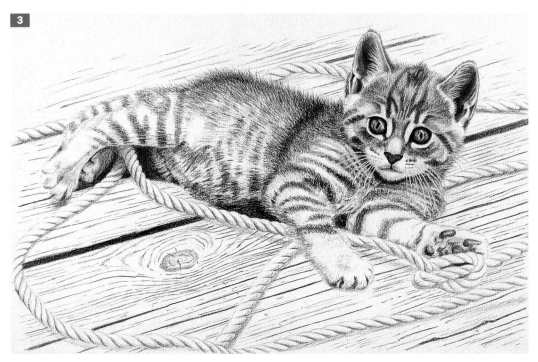

STEP THREE I lightly apply magenta over the insides of the ears. Then I add light layers of magenta and dark umber to the paw pads, using circular strokes for a soft blend. I soften the black rims around the eyes with dark umber and also add dark umber to the stripes in the fur. I add some more black to the dark grays in the fur and darken some areas of the chest and front legs, using short, tapered strokes that follow the direction the fur grows. Then I add dark umber to the stripes and the darker areas of the hind legs, using a blending stump to soften the colors. Next I add a ring of dark umber to the eyes around the pupils, and then I use dark umber to draw over the black detail lines in the wood.

STEP FOUR Next I layer cobalt blue over the irises in the eyes, saving the white highlights. To deepen the shadows, I apply some blue over the chin area, under the neck, along the shadow side of the front legs, and in all the shadowed areas of the rope. I also add a little blue to the back leg and the tail to "push" them back a bit. I add a touch of yellow to the eyes between the iris and the pupil. Next I apply yellow to the rope, putting a slightly heavier layer over the strand in the foreground. Then I layer a little black over the rope's blue cast shadow to darken it.

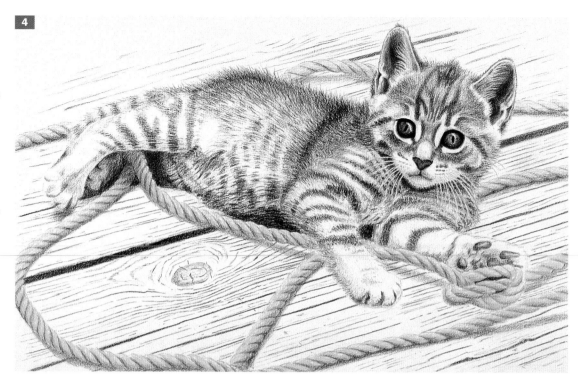

STEP FIVE I apply cobalt blue to the dark cracks of the deck and add a few light strokes of magenta in front of the kitten. Then I add magenta to the shadow under the rope, creating a purple hue. I add a shadow under the knot in the rope and then apply another light layer of dark umber to darken the wood. I lightly add a few spots of yellow and use a blending stump to soften the colors. Then I draw the kitten's fur over the wood with black, making short strokes that start at the body and go out in slightly different directions. I refer to my photo here, matching it carefully to render this kitten's particular fur pattern.

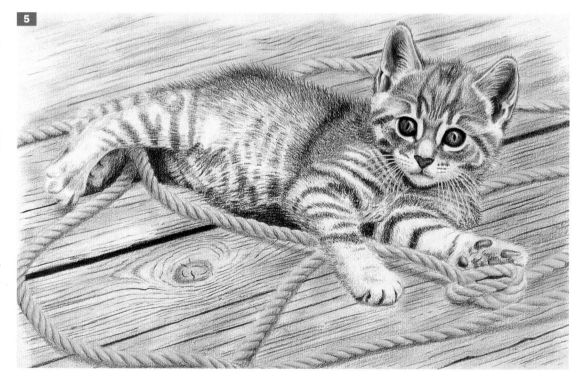

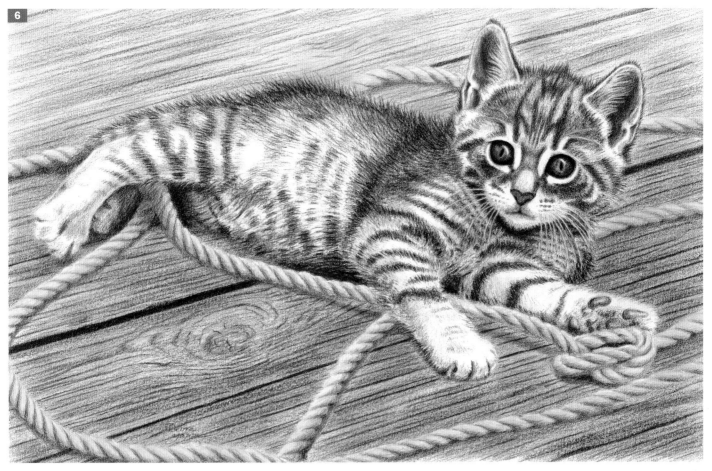

STEP SIX I soften the fur even more by blending short strokes of white over some of the black. Then I draw white over the whiskers and add a few hard strokes of white through some of the darker areas (such as the belly) to show the texture of the fur. I add a little more cobalt blue, dark umber, and yellow to the eyes, and then I finish with a layer of white to soften and blend the colors. I also add white to the tiny tufts of fur in the ears. I decide the stripes on the legs look a little thin, so I widen them with short black strokes.

Then I darken the shadows under the ropes in a few places with a little more blue and black, but I keep the shadow lighter than it appears in the photo to reatain the focus on the kitten. I use white to soften the colors in the rope, and then I turn the drawing upside down again to check the values. I decide to darken the wood a little more, so I add some black and dark umber, mostly in the foreground. Finally I apply a light layer of yellow to warm the color of the wood.

Starting with Black and White

Many colored pencil artists begin with a black-and-white value drawing; this method is called "grisaille." Grisaille allows the artist to establish the darks and lights in a subject before applying color. Then, as the transparent colored pencil values are layered over the initial drawing, the dark values lend additional depth to the darkest areas. The example below demonstrates how the grisaille technique helps build volume in a simple scene.

Art by Pat Averill

Graphite underdrawing

First layer of color

Final drawing

Lesson 5: Portrait

Achieving a Likeness

Portraits have been extremely popular subjects for centuries; there is nothing quite as exciting as capturing a human personality on paper. You can accurately depict the likeness of a person by carefully observing and copying the shapes, values, and colors you see. Begin by dividing the face into thirds, and note where the features fall in relation to the whole face and to one another (the *proportions*). Then, as you do when drawing animals, look for what makes each person unique. In this portrait of Liza, Debra communicates the girl's charming innocence by paying close attention to proportion and detail—including her wide smile, wispy curls, and adorable dimples.

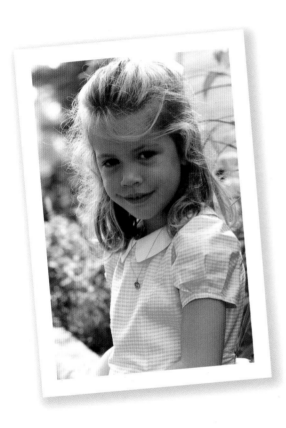

DRAWING CHILDREN When drawing a portrait, it's important to work out the details and proportions in a sketch before you begin applying color. For example, in this photo reference, you can see that the halfway mark between the top of the head and the chin is just about at eye level. When the sketch is complete, I transfer the drawing of Liza to my art paper.

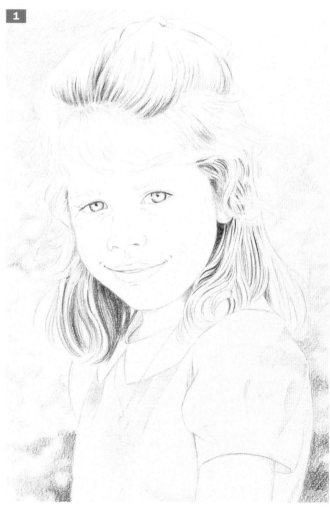

STEP ONE Using light, short strokes of black, I begin by placing some shadows on the dress. I create a loose indication of flowers in the background and a dark, leafy area near the bottom. Next I apply black in a circular motion to smooth out the background, drawing around the lighter areas. Then I indicate the shadows in the hair with soft black lines that follow the direction in which the hair curls.

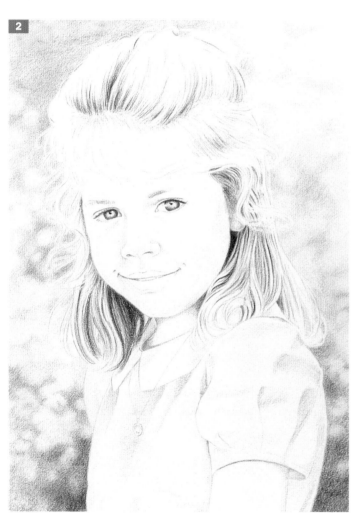

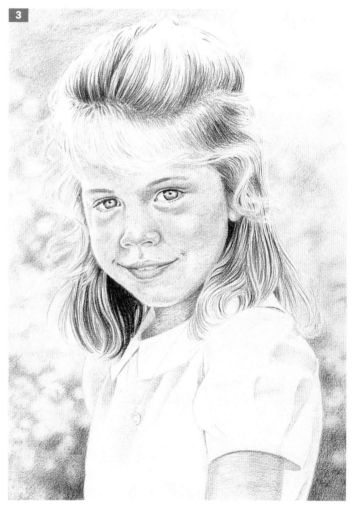

STEP TWO Next I lightly indicate the eyebrows with black, stroking in the direction they grow. I lightly apply cobalt blue to the shadows on the face and arm, and then I layer blue over the black lines in the hair to soften them and make them less stark. I also add a little blue to the white of the eyes and under the eyelashes to give the eyes some dimension. Then I apply blue over the shadows on the dress and add a little more black in the background. I give most of the background a light layer of blue, pressing harder over the black areas that I want to appear a bit darker. I leave the wisps of hair along the sides of the face white by coloring around them with the background colors. Then I use a blending stump to blend the blue into the background.

STEP THREE I layer dark umber over the black lines in the hair, pressing firmly in the dark areas. Then I lightly apply dark umber to the rest of the hair, leaving the highlights white. I softly add dark umber to the crease of the eyelids, the corners of the mouth, and the dimples that make her expression so unique. I also apply a light layer of dark umber to the lips, leaving the highlight on the bottom lip white. Next I detail the eyelashes with dark umber, starting at the lid and curving them out. Then I make the eyebrows a little darker with black.

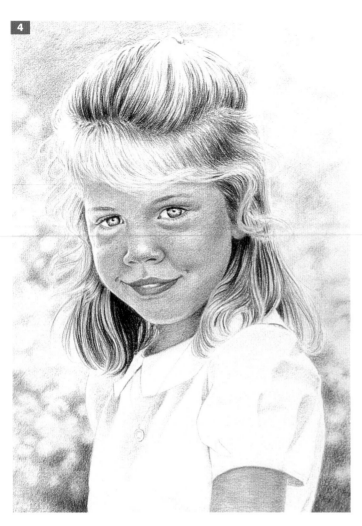

STEP FOUR To establish a base for the skin tones, I add a smooth, light, layer of magenta to the face and arm, leaving the highlighted edge of the cheek white. Then I use a blending stump on the skin tones to lightly blend the colors. Where the face appears too red, I pull some pigment off with a kneaded eraser. Then I apply a little magenta to the inner corner of each eye and add a light layer of yellow over the hair and face. Next I darken the hair with a little more dark umber and lightly indicate a few freckles on the nose and cheeks.

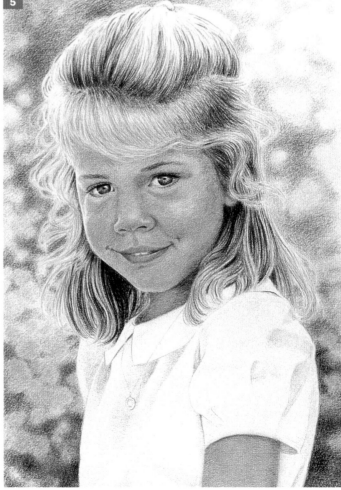

STEP FIVE Now I apply a light layer of peach in the whites of the eyes, leaving a small white highlight in the center of each pupil. I also add a light layer of peach to the teeth (since they are in shadow and shouldn't be pure white) and to most of the face, leaving highlights on the nose and bottom lip. Next I softly apply peach to the high-lighted edge of the cheek, smooth-ing the transition from color to white. In the background, I add areas of dark umber, dark green, and black to the smooth, circular shapes. Then I apply green over the black in the top-left and bottom-right corners. Next I add a bit more brown to the arm and sleeve to cre-ate a sense of depth and realism.

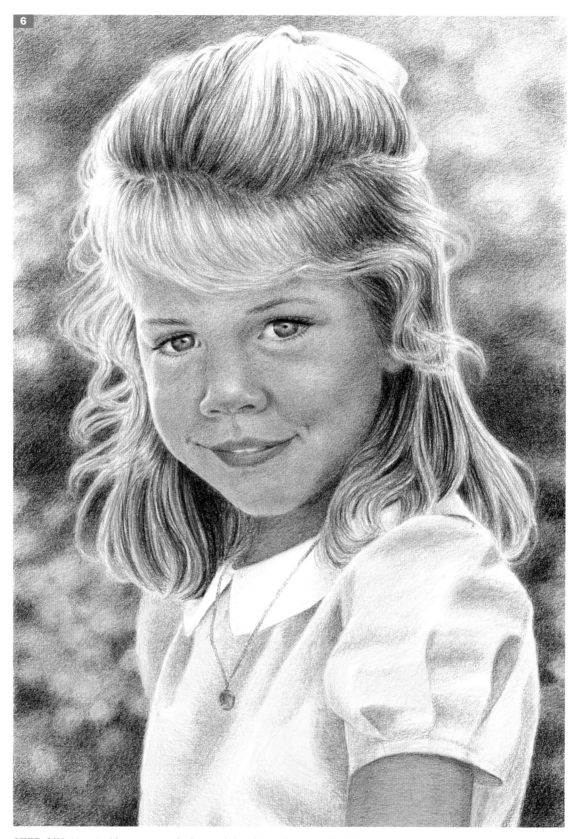

STEP SIX Here I add magenta to the hair and then layer white over the darks. I use dark umber to draw the necklace and locket, and then I add yellow. I apply dark green and magenta to the background and then use cobalt blue to soften the colors. I lightly layer magenta and then dark umber over the blue shadows on the dress and blend with a stump. Then I apply yellow over the dress, leaving highlights as needed. I lightly layer blue along the right side of the face, along the hairline and cheek, to round out the face. Finally I soften some of the wisps of hair and darken the eyelashes and eyebrows.

Conclusion

Once you've explored the variety of subjects and techniques offered here, we hope this book will continue to be a reference tool as you advance as a colored pencil artist. In addition, classes and workshops are offered through many art centers, retail stores, and adult learning centers, and you can always learn more from experimenting with other tools, techniques, and colors.

Continue to explore what works best for you, and always keep looking for unique and interesting subjects to inspire you. Don't be afraid to try something new and challenging, and don't worry about making mistakes. You can always make the next drawing better than the last. Use your imagination, and soon you'll discover your own style and approach to the medium. Most of all, we hope you enjoy all your artistic adventures in colored pencil!